Cats Rule!

Snap
books®

Cat
SPEAK

Revealing Answers to the Strangest Cat Behaviors

by Maureen Webster

CAPSTONE PRESS
a capstone imprint

Snap Books are published by Capstone
1710 Roe Crest Drive, North Mankato, Minnesota 56003
www.mycapstone.com

Library of Congress Cataloging-in-Publication Data
Cataloging-in-Publication data is on file with the Library of Congress.
ISBN 978-1-4914-8400-5 (library binding)
ISBN 978-1-4914-8412-8 (eBook PDF)

Editorial Credits
Carrie Sheely and Alesha Halvorson, editors
Philippa Jenkins, designer
Svetlana Zhurkin, media researcher
Steve Walker, production specialist

Printed and bound in US

We would like to thank Laurie Patton, Regional Director, TICA Southeast, for her invaluable help in the preparation of this book.

Photo Credits
Capstone Press: Philippa Jenkins, back cover and throughout; Courtesy of the Door County Humane Society, 27; Shutterstock: A. Krotov, 26, Anna Hoychuk, 14, bmf-foto, 8, Carsten Reisinger, 19, Cressida Studio, 10, Eric Isselee, 7, 13, 28, esdeem, 15, gurinaleksandr, 9, gvictoria, 24, HamsterMan, 12, Hans Engbers, 25, IrinaK, cover, Joop Snijder Photography, 20, Komar, 23, Kuiper, 17, Molpix, 22, Orhan Cam, 18, Phant, 5, piotrwzk, 16, SJ Allen, 21, TungCheung, 11

Table of Contents

Why Does My Cat Do That?

Your cat follows you into the kitchen. She pads along behind you and attacks your heels. You reach down to pet her. Is she asking for some attention? She looks up at you and almost closes her eyes while you touch her. She likes this!

You turn and walk toward the sink. You're thirsty. On goes the cold water. Your cat leaps onto the counter. Her head dips under the faucet to catch the final drips. You turn off the water. She looks at you with pleading eyes. On goes the faucet with a slow drip now. Your cat drinks from the faucet. She isn't bothered when her fur gets wet. She stays there until she's satisfied. This has happened before. It's just one of your cat's unique behaviors!

Have you wondered why cats act the way they do? People who study cats have decoded some of these mysterious behaviors to help you understand our feline friends. If you know a cat, see if you can figure out what it's trying to tell you!

Did You Know?

Have you ever seen cats hanging around together? A group of cats is called a clowder.

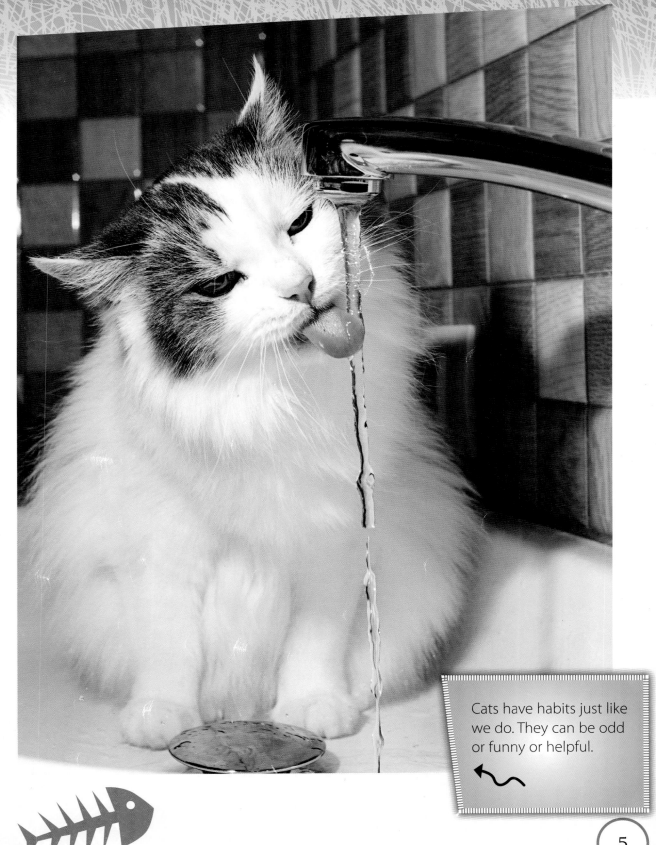

Cats have habits just like we do. They can be odd or funny or helpful.

Cats use their senses to understand the world. You can use your senses of sight and hearing to get to know cats. It may take time, but it'll help you understand what cats are trying to communicate.

Mood Clues

Cats' faces aren't as expressive as dogs' faces. Cats can blink their eyes, yawn, or show their teeth. But their facial expression doesn't change much. To understand what a cat is feeling, watch its body signals. Ear position gives information on a cat's mood:

	Ears forward with half-closed eyes	The cat is content.
	Twitchy ears	The cat is unsure of its feelings.
	Folded-down ears	The cat is fearful.
	Ears jutting forward	The cat is curious and wants to hear well.
	Ears curled back while whiskers are forward	The cat is angry.

A cat's tail also gives clues to its mood:

	If the tail fur is puffy	The cat is angry or frightened.
	An upright tail with flat fur	The cat is curious or happy.
	A tail hanging low or between the legs	The cat is insecure or anxious.
	A quivering tail standing straight up	The cat is happy or excited.
	If the tail is thrashing back and forth	The cat is upset; the faster the tail moves, the more upset it is.

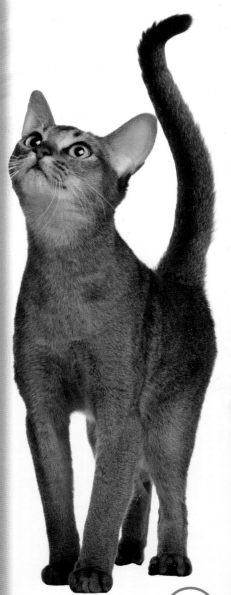

Scents Make Sense

Cats also communicate using scent. When a cat knows another cat well, they'll touch noses. This is a way for cats to show they recognize each other.

Marking allows a cat to leave a message for other cats that come into their space. Cats mark territory with scent by rubbing against items with their cheeks and **flanks**. Cats have scent glands in these areas. The scent stays on the object and tells the other cats to stay away. Cats mark humans the same way.

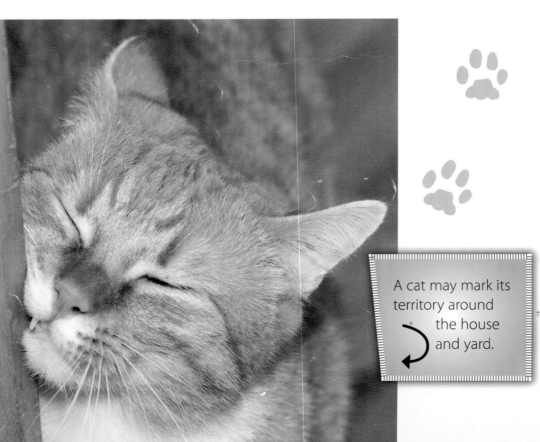

A cat may mark its territory around the house and yard.

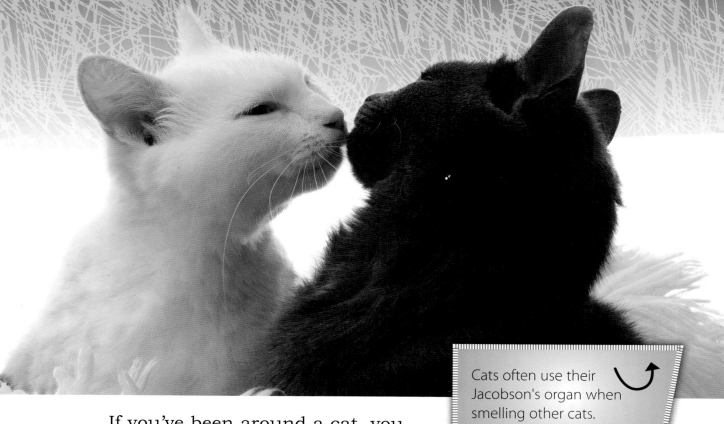

Cats often use their Jacobson's organ when smelling other cats.

If you've been around a cat, you may have noticed it make a strange face after sniffing something. Smell is so important to cats that they have an extra **olfactory** organ called the Jacobson's organ. It's in the roof of its mouth but is connected to its nose. When a cat smells something unusual, it'll sniff it. The cat then opens its mouth to let the scent flow over the Jacobson's organ. It gives the cat more information about where the scent came from.

flank—the part of a cat's body between the bottom rib and the hip
olfactory—having to do with the sense of smell

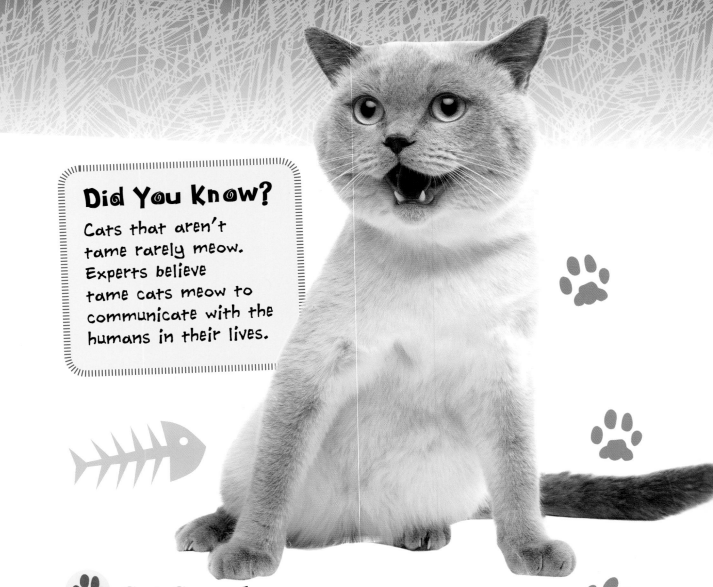

 Cat Sounds

Cats can make more than 100 different sounds. The classic meow is the one cats use most. Yet meows can sound different from one another and have different meanings. A soft meow might be the way a cat greets people. A loud meow can be a demand for food. A high-pitched meow could mean the cat doesn't want to be touched. Cats learn how owners react to specific sounds. They change the sound of their meow to get their needs met.

Purring is the sound of a mellow cat. Or is it? Scientists aren't sure. Cats purr when they are snuggled on a lap. Cats also purr when they are injured, sick, and anxious. A purr may be a way for a cat to comfort itself. Maybe someday this purr-fect mystery will be solved.

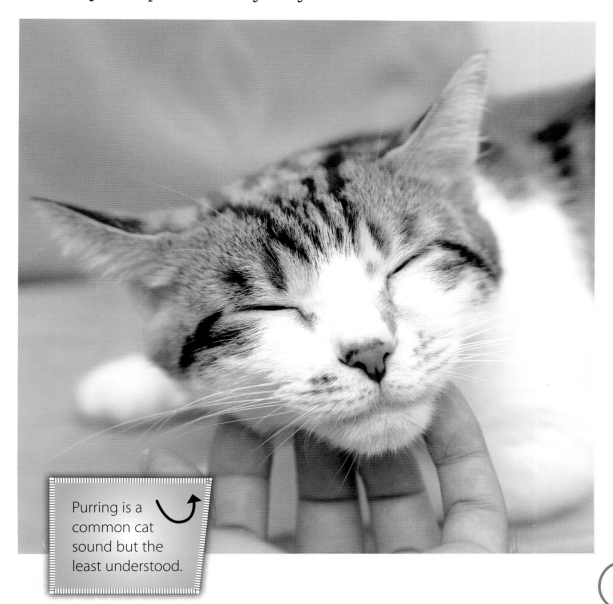

Purring is a common cat sound but the least understood.

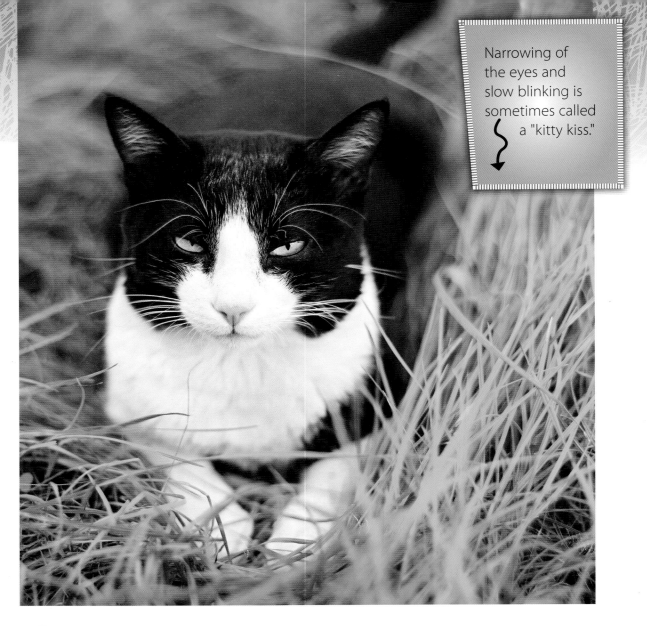

 ## Blink Those Eyes

When a cat blinks and narrows its eyes at another cat, scientists believe it is sending a feline message of friendship. Cats can also give humans this sign of affection, and humans can return the love. Try to make friends with a cat. Gaze at it. Slowly blink. See if the cat blinks back at you.

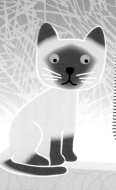

Did You Know?

The oldest living domestic cat in the world lived to be 38 years old. Crème Puff lived in Austin, Texas, and died in 2005. The average lifespan of an indoor cat is 15 years.

Chatty Cats

Some cat breeds don't meow much, but others have a lot to say. Siamese cats are the most vocal breed. They can imitate a baby's cry. This cat will always tell its owner what it needs and when. But its high-pitched meow can be annoying!

The Tonkinese cat loves to greet visitors at the door to talk nonstop in its friendly voice. This cat also has a powerfully loud purr.

The large, longhaired Maine Coon cat talks to people in a melodic, chirpy voice. The Maine Coon's chatter can sound like it's asking questions because of the rising tone at the end.

domestic—tamed

13

Cat Behavior and People

Cats have lived with people for thousands of years. But people sometimes consider cats to be selfish and distant. Is it true? Or are they just very self-reliant?

 ## Why Does My Cat Ignore Me?

Some cats are friendly and others are timid. A cat's personality depends a great deal on its **genes** and the early kitten experiences it has. If a kitten has been cuddled and taught how to play by its mother, the adult cat will often be friendly.

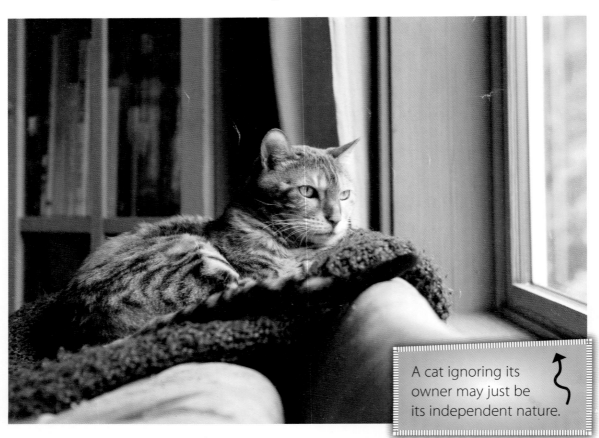

A cat ignoring its owner may just be its independent nature.

Cats That Act Like Dogs

Abyssinian, Burmese, and Manx cats each have qualities that are similar to dogs. Many Abyssinian cats love water. They play fetch and want to be involved in whatever their owners are doing. They even can be trained to walk on leashes. Burmese cats are friendly cuddlers. They like to play with children and follow their owners around. Manx cats are friendly and affectionate. They love to be around people. These cats can be trained to answer commands such as "come" and "no."

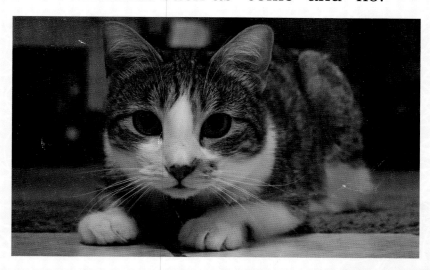

Most cats don't need as much attention as dogs do. A cat's wild **ancestors** lived and hunted alone. Some of that wild independence still exists in domestic cats. Dogs are different. They are pack animals and need to be with humans or other dogs to be happy.

gene—a part of every cell that carries physical and behavioral information passed from parents to offspring
ancestor—a member of a person or animal's family who lived a long time ago

15

 ## A Cat in Your Lap

Has a cat ever jumped into your lap and started purring and **kneading** its paws? Why in the world does it do this? It's repeating happy behavior from when it was a kitten. Kittens knead their mother's skin to get the milk flowing. If a cat is kneading you with its paws, it usually means that it's very happy.

When a cat leaps into your lap and begins to snuggle, it's one of the friendly behaviors a cat does to communicate pleasure. It's saying it wants to be friends. Return the love with some petting.

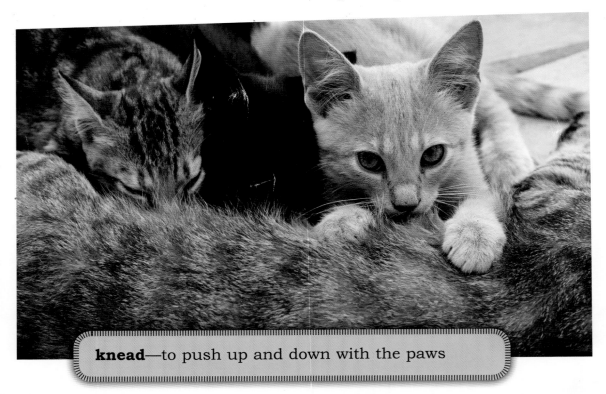

knead—to push up and down with the paws

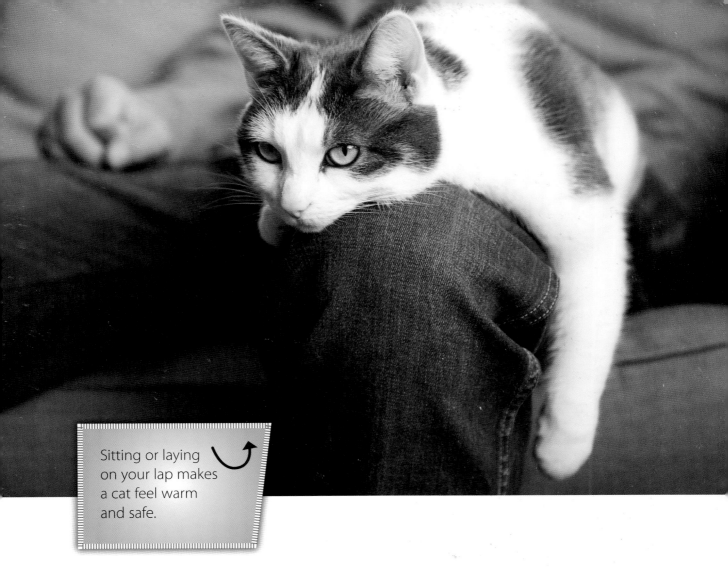

Sitting or laying on your lap makes a cat feel warm and safe.

 ## Don't Touch Me!

What is a cat communicating if it won't let you pick it up? It may mean the cat is sensitive to having its tail or spine touched. Or maybe it doesn't like cuddling. Pay attention. Cats tell us what they like or don't like in very firm ways. A usually happy cat that starts biting or scratching when its belly is rubbed is telling you to stop—now! The belly is a sensitive area for many cats. Touching it can make them feel uncomfortable.

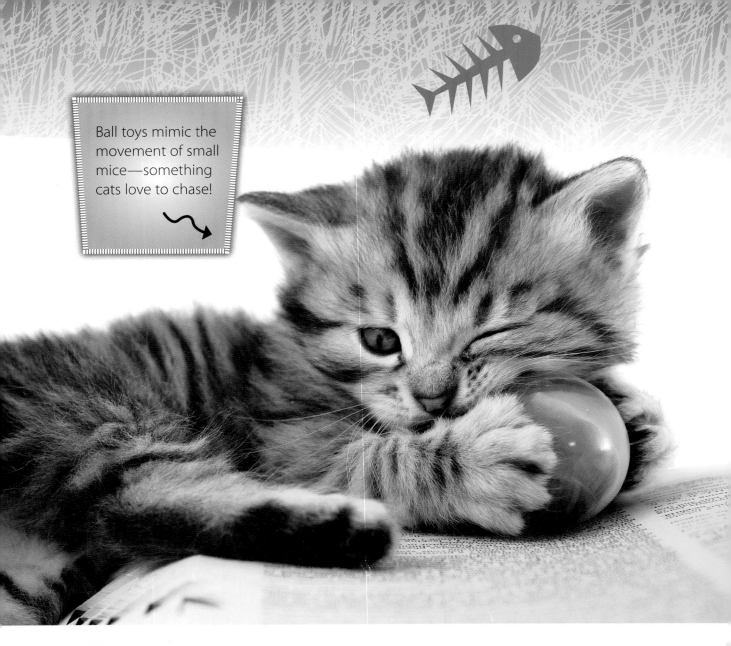

Ball toys mimic the movement of small mice—something cats love to chase!

 Old Household Habits

Cats like to chew on objects that have different textures. Chewing on electrical cords, plastic or metal blinds, or fabric can be dangerous. Cats will sometimes chew if they're feeling bored or stressed. Help your cat release its boredom by providing toys for chewing.

Some cats may eat nonfoods, such as fabric or elastic bands. This behavior is called **pica**. It may begin at a stressful time in a cat's life, such as when it moves to a new home or its owners get another pet. To discourage pica, play with your cat often and keep nonfood items your cat wants to eat stored away. Also check with your veterinarian to make sure your cat doesn't have any medical problems that are causing the pica.

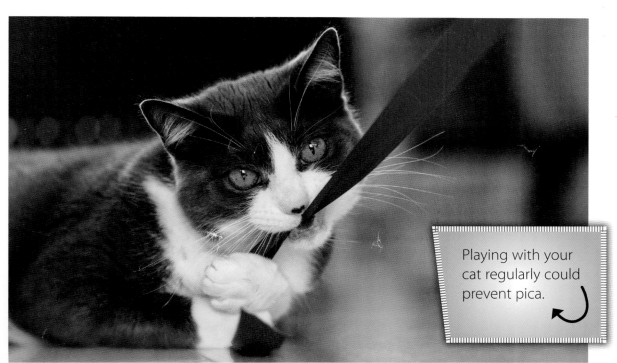

Playing with your cat regularly could prevent pica.

pica—the urge to eat things that aren't food

CHAPTER ③

The Hunter Cat

You feed your cat every day. But cats are hunters at heart. Before cats were bred to be indoor pets, they lived independently in the wild. They hunted for food and protected themselves. Many indoor cat actions imitate hunting behaviors passed down through their ancestors.

Hunting Play

The cat crouches around the corner of the kitchen. Human footsteps come near. The cat gets very low to the ground. The human walks by. The cat pounces on the person's shoes. The human runs. The cat chases and nips at the person's heels. The cat is showing hunting behavior.

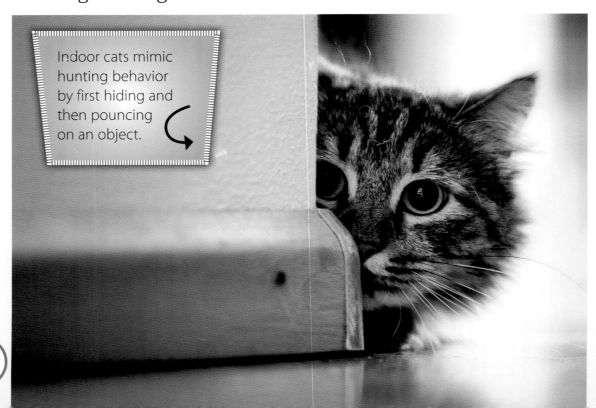

Indoor cats mimic hunting behavior by first hiding and then pouncing on an object.

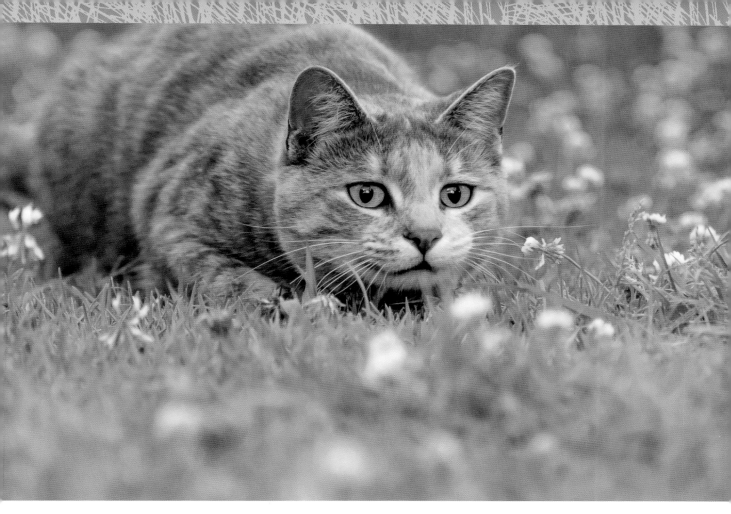

Moving things attract a cat to pounce and play. A crumpled piece of paper batted around is like an active game of mouse-hunting for a cat. A piece of string moving up and down might catch a cat's attention. The cat waits with its claws out to strike at its **"prey."** A laser pointer dot moving around a dark wall also might make a cat go into hunting mode. People using knitting needles or pencils can cause a cat to follow the motions and use its hunting skills.

prey—an animal hunted by another animal for food

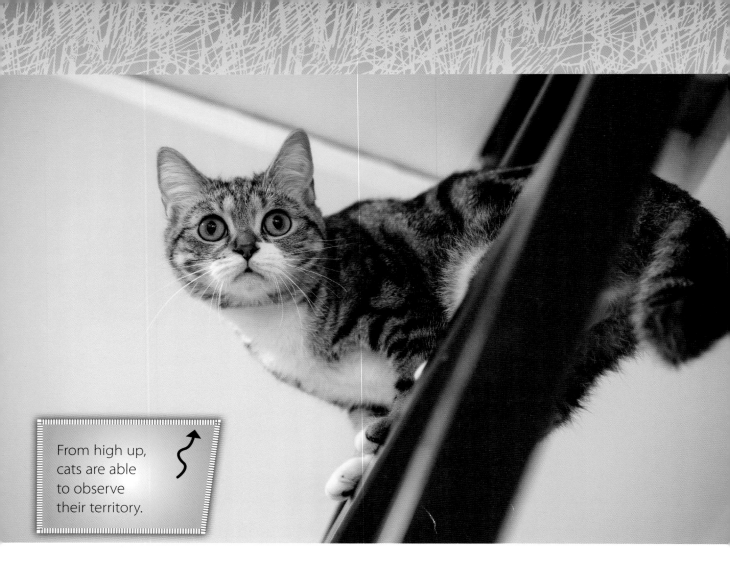

From high up, cats are able to observe their territory.

Up High and Tucked In

Many cats climb up on top of refrigerators or other high places. From this view, a cat watches all that is happening from a safe location. But it isn't always safe—be watchful of where your cat climbs.

Have you ever seen a cat turn a paper grocery bag on its side and crawl inside? Cats like to "own" small spaces and hide from us. It makes them feel safe and secure. When a cat is anxious, hiding is a way to gather confidence.

Gee, Thanks!

When cats bring home a dead mouse, most owners think it's a gift. But recently scientists have said this isn't the case. It's natural for cats to hunt. When they catch prey, their **instincts** tell them to return home with it. Experts think domestic cats forget they don't need to hunt until they walk in the door. So they leave the prey on the ground or floor.

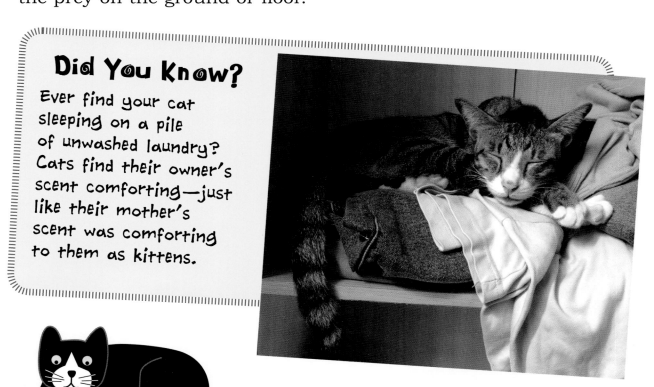

Did You Know?

Ever find your cat sleeping on a pile of unwashed laundry? Cats find their owner's scent comforting—just like their mother's scent was comforting to them as kittens.

instinct—a behavior that is natural rather than learned

Mysterious Behaviors and Abilities

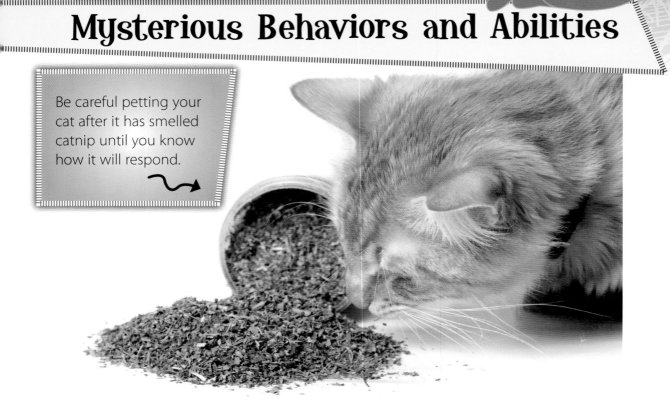

Be careful petting your cat after it has smelled catnip until you know how it will respond.

Some things cats do continue to mystify animal experts. These are the behaviors that cat owners love to tell stories about. In some cases, experts think they can explain parts of odd behaviors, but other parts aren't yet fully understood.

Catnip

Catnip can bring out a variety of behaviors in a cat. This herb can cause a cat to feel happy. A cat might flip and twist its body on the floor after sniffing catnip. Yet the scent makes some cats growl, run around the house, or become very protective of their toys. Scientists aren't sure, but they think that the oils in catnip stimulate a cat's brain and cause these behaviors.

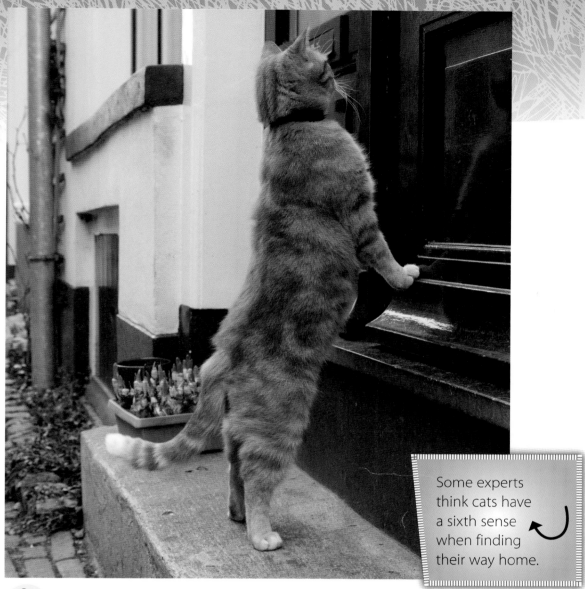

Some experts think cats have a sixth sense when finding their way home.

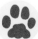 Going Home

Many true stories exist of both wild and domestic cats finding their way home over hundreds of miles. How? It may be an extra-developed sense of time and direction. Some people say these cats use the sun and stars to find their way home. Or they use their memory to guide them back to their owners. Scientists aren't exactly sure about this built-in sense of navigation. It's another example of amazing cat behavior that needs to be studied.

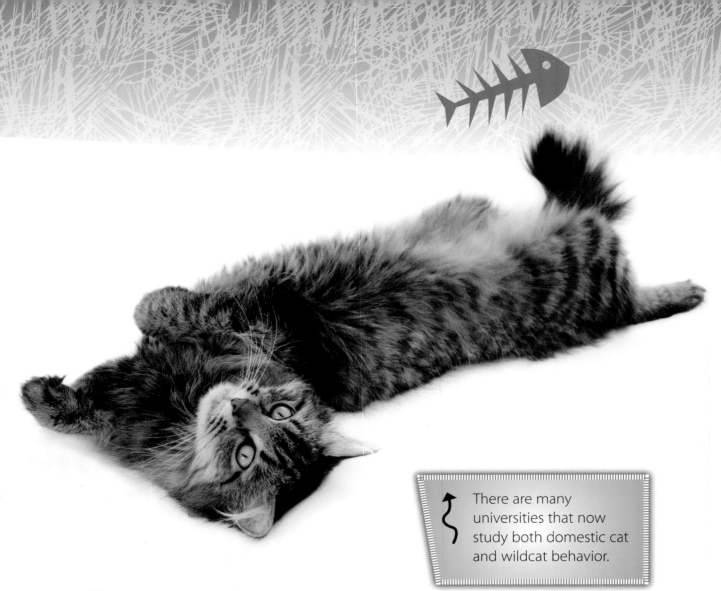

There are many universities that now study both domestic cat and wildcat behavior.

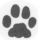 Learning about Cats

To live with a cat is to know a cat. Their behaviors may be simple to understand or very strange. Cats still carry many traits from their wild ancestors. Their actions both entertain and mystify us. Science gives us some answers to their puzzling behaviors today. Maybe future research will give us an even better understanding of our feline friends.

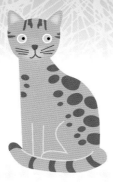

A Hero Named Pudding

The night Amy Jung brought her cat Pudding home won't be forgotten. In February 2012 Amy adopted Pudding from an animal shelter in Sturgeon Bay, Wisconsin.

That night Amy, who has **diabetes**, had a **seizure** in her sleep. Pudding sat on Amy's chest and swatted at her face. Amy woke up and shouted to her son, Ethan. But Ethan didn't hear her. So Pudding bounced on Ethan's bed until he woke up. Ethan called for help. Amy survived, and Pudding was a hero! Pudding is now a therapy cat. His most important job is to sit at Amy's feet and meow when he senses her blood sugar is low.

diabetes—a disease in which there is too much sugar in the blood
seizure—a sudden attack that causes a person to lose consciousness

Teach Your Cat to Do Tricks

How about teaching your cat a few tricks? Cats are more motivated by play, but a treat and lots of praise will seal the deal. They also need lots of chances to practice the trick. Start simple and have patience.

 ## Shaking Hands

Even an older cat can master this trick. Teach for only 10 minutes at a time. Always do it before a meal at the same time each day.

1. While your cat is sitting still, grasp one paw in your hand. Hold a treat in your other hand.

2. Move the paw you're holding up and down, as if you're shaking hands. Release your grip on the paw but push it up in the air. When the paw comes back down into your hand, grasp it and say your cat's name and "shake."

3. Immediately reward your cat with a treat and say, "Good shake."

4. Repeat this lesson again. If the cat begins to raise a paw on his own, give it an extra treat.

Jumping Through Hoops

This trick requires a training device called a clicker. Buy one at any pet supply store. Train your cat to connect the sound of the clicker to receiving a treat. Click-treat-repeat. Do this several times. Soon your cat will be ready to do this fun trick.

1. Find a Hula-Hoop.

2. Hold the hoop on the ground between you and the cat. Sit in front of the hoop holding the clicker and a treat.

3. Click and offer the treat after the cat walks over the hoop to your side.

4. With more practice, you can speed up the clicker or lift the hoop off the ground and see if your cat will jump through it.

5. Get a friend to help you and try teaching your cat to jump through two hoops.

Glossary

ancestor (AN-sess-tur)—a member of a person or animal's family who lived a long time ago

diabetes (dye-uh-BEE-teez)—a disease in which there is too much sugar in the blood

domesticated (duh-MESS-tuh-kay-ted)—tamed

flank (FLANGK)—the part of a cat's body between the bottom rib and the hip

gene (JEEN)—a part of every cell that carries physical and behavioral information passed from parents to offspring

instinct (IN-stingkt)—a behavior that is natural rather than learned

knead (NEED)—to push up and down with the paws

olfactory (uhl-FAK-tree)—having to do with the sense of smell

pica (PYE-kuh)—the urge to eat things that aren't food

prey (PRAY)—an animal hunted by another animal for food

seizure (SEE-zhur)—a sudden attack that causes a person to lose consciousness

Read More

Carney, Elizabeth. *Cats vs. Dogs*. Washington, D.C.: National Geographic, 2011.

Guillain, Charlotte. *Cats*. Animal Family Albums. Chicago: Raintree, 2013.

Miles, Ellen. *Guide to Kittens*. Kitty Corner. New York: Scholastic, 2013.

Thomas, Isabel. *Cool Cat Projects*. Pet Projects. Chicago: Raintree, 2016.

 Internet Sites

FactHound offers a safe, fun way to find Internet sites related to this book. All of the sites on FactHound have been researched by our staff.

Here's all you do:

Visit *www.facthound.com*

Type in this code: 9781491484005

 Check out projects, games and lots more at
www.capstonekids.com

 # Critical Thinking Using the Common Core

1. Why do cats touch noses? Explain why scientists think cats do this. (Key Ideas and Details)

2. Name two ways cats are different than dogs. Then use other online or print resources to name two other ways dogs are different from cats in their behavior. (Integration of Knowledge and Ideas)

3. Look at the picture on page 7. How do you think the cat is feeling? Name two reasons that support your answer. (Craft and Structure)

Index

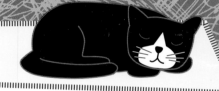